The Floating World

An Evocation of Old Japan

Universe Books
New York

Published in the United States of America in 1979
by Universe Books
381 Park Avenue South, New York, NY 10016
in cooperation with
The Minneapolis Institute of Arts

© 1979 by Universe Books and The Minneapolis Institute of Arts
All rights reserved

Second printing, 1989

Library of Congress Catalog Number 78-68848
ISBN 0-87663-993-7
Printed in the United States of America

Front cover:
Unknown
GIRL DANCING WITH A FAN
Kakemono (perhaps a panel from a small screen). Ink, colour, and gofun on aged paper; 21¾ x 10⅞ in; c. 1640–50

Back cover:
Katsushika Hokusai
TORU-NO-DAIJIN
Kakemono-e. Colour print; 20³⁄₁₆ x 9⅛ in; c. 1830-3

Frontispiece:
Miyagawa Isshō
A GIRL STANDING BENEATH A FLOWER ARRANGEMENT
Kakemono. Ink, colour and gofun on paper; 29½ x 12¼ in; c. 1750

Overleaf:
Kawanabe Kyōsai
THREE CROSSBILLS ON A TREE
Kakemono. Ink and colour on paper; 53¼ x 24 in; c. 1878

Pictures and Poems
of the Floating World

For 250 years, from 1603 to 1867, the people of Edo (now called Tokyo), under the rule of Tokugawan shoguns, enjoyed a peace that brought to many the prosperity and the leisure to develop a spirited interest in the popular arts, in nature, and in stylishly pleasurable living. This was a time when audiences so passionately supported favorite Kabuki actors that they formed rival groups and fought in the streets, and when Edo, with 1,300,000 inhabitants, had 3,000 courtesans in a quarter known as Yoshiwara ("the nightless city").

In the *ukiyo-e* ("pictures of the floating world") presented in this book, Tokugawan artists vividly depicted the beautiful women, the heroes, the latest fashions, and the everyday scenes of their changing, passing world in a style that was immensely popular with the people of the time. Harunobu designed nearly one thousand color woodblock prints in six years, Utamaro over two thousand in his career, and Hiroshige close to ten thousand. And their woodblock prints were produced in editions of many copies to satisfy the public demand.

Now Edo is gone, the courtesans and Kabuki actors are gone, and so are the artists who portrayed them. Yet, here in our midst are the Tokugawan images of a floating world, passed on through the centuries, to be viewed by us in a very different culture at a much later time. Perhaps part of our appreciation of the *ukiyo-e* lies in our ability to see reflected in them, not mere scenes from a remote and foreign past, but ourselves, our passing concerns, and our floating world.

Facing each of these images—landscapes, snowscapes, birds, animals, beautiful women, brave warriors, and delicate scenes of daily life—are brief, evocative poems that relate spiritually to the adjacent art. Japanese poetry is a living part of Japanese society and culture. Classical five-line *tankas* of 31

syllables are as well known today as when they were written 1,500 years ago. The 17th-century three-line *haiku* of 17 syllables still lives, reincarnated in clichés of everyday speech. Every New Year thousands of men and women submit entries for the emperor's poetry prize, and several times a year people on all levels of society contribute to local poetry magazines. Japanese poems, like the pictures of the floating world, leave out everything that is not essential. Their subject matter, by Western standards, is comparatively limited: the cherry blossoms of spring, the crickets and fireflies of summer, the first cold winds and falling maple leaves of autumn, the snows of winter, the absence of a loved one, the pleasure or melancholy of solitude.

The translations included here are adapted from Basil Hall Chamberlain, Lafcadio Hearn, and several other sources.

Kitagawa Utamaro
WOMAN MAKING A FLOWER ARRANGEMENT
Kakemono. Ink, colour and gofun on paper; 15½ × 19½ in.; c. 1802

How frail the cherry blossoms are!
Like human life,
the petals drift down
while we gaze at them,
as soon as they come out.

—*Kokinshū*

Tsunemasa
YOUTH PLAYING A SHOULDER DRUM
Kakemono. Ink, colour and gofun on silk; 18 × 23⅛ in.; c. 1750

I know not if his love will endure;
but my thoughts, this morning,
are not less tossed
than my black hair.

—Anon.

Kitagawa Utamaro
THE FARMER'S WIFE
Ōban colour-print; 14¼ × 9¾ in.; c. 1795

苗代の
とめおかぬ
なくし

Although I cannot clearly see autumn,
I know by the noise of the wind
that it has come.

—Fujiwara Toshiyuki

Utagawa Toyokuni
SAWAMURA SŌJŪRŌ III AS UMA NO SAMURAI
Ōban colour-print; 15 × 10⅜ in.; 1797

People who interrupt your stories
to show off their own cleverness
are detestable.
All interrupters,
young or old,
are detestable.

—Makura Zōshi

Kabukidō Enkyō
THE ACTOR NAKAZŌ II AS MATSUŌ-MARU
Ōban colour-print; 14³/₁₆ × 10 in.; 1796

津川かん 嵐三五郎

鳥居清信筆

The very names of Heaven and
 Earth
will cease to be
before you and I shall cease
to see one another.

—Manyōshū

Torii Kiyomasu
THEATRICAL DUO
Print: hoso-ban, urushi-e, hand-coloured; 12⅛ × 6⅛ in.; c. 1730

When you have gone away
no flowers will remain,
no maple leaves in all the world,
till you return to me.

—Yanagiwara Yasu-ko

Tamara Suiō
NARIHIRA'S JOURNEY EAST
Kakemono. Ink, colour and gofun on silk; 14¾ × 22⅞ in.; c. 1710

If there were no gods whatever,
on earth below, in heaven above,
then might I die without once more
meeting my love.

—Nakatomi Yakamori

Katsushika Hokusai
TOBA IN EXILE
Kakemono-e colour-print; 20³/₁₆ × 8⅜ in,. c. 1830-3

People are detestable who,
when you are telling a story,
break in with
"Oh, I know,"
and give quite a different version
from your own.

—Makura Zōshi

Utagawa Toyokuni
IWAI HANSHIRŌ IV AND KATAOKA NISAEMON VII IN A PLAY
Ōban colour-print; 14⅞ × 10 in.; 1796

What am I to do with my sister
whom, like the Judas-tree
which grows in the moon,
I may see with my eyes
but not touch with my hands?

—Yuhara

Suzuki Harunobu
'CROW AND HERON'
Chūban colour-print; 10¼ × 7¾ in.; c. 1766

Since all that lives
must die some day,
I shall enjoy myself
as long as I remain in this world.

—Ōtomo Tabito

Kitao Masanobu
GEISHA ON HER WAY TO A NIGHT-TIME ASSIGNATION
Kakemono. Ink and colour with gofun on silk; 36½ × 16½ in.; c. 1784

Hateful in my eyes
is the sententious prig
who will not drink saké.
When I look on such a one
I find he resembles an ape.

—Ōtomo Yamakochi

Utagawa Toyokuni
COURTESAN WITH *SAKE* CUP
Kakemono. Ink, colour and gofun on silk; 34½ × 12 in.; c. 1794

Listening to the nightingale singing
among the flowers
or to the cry of the frog
which dwells in the water,
we recognize the truth
that of all living things
there is not one
which does not utter song.

—Ki Tsurayuki

Chōbunsai Eishi
A WOMAN AS THE POET BUNYA NO YASUHIDE
Ōban colour-print; 15⅛ × 10⅛ in.; c. 1795

Wert thou a jewel,
I would wear thee in my bracelet.
Were thou a garment,
never would I find time to undress me.

—Anon.

Suzuki Harunobu
GIRL CLOSING HER EARS TO THUNDER
Chūban colour-print; 11 × 8⅔ in.; c. 1766-7

To the samurai
first of all comes righteousness,
next life,
then silver and gold.

—Kyusō

Utagawa Toyokuni
BANDŌ MITSUGORŌ II AS ISHII GENZŌ
Ōban colour-print; 14¾ × 10⅛ in.; 1794

Hearing the sound of horse's hoofs,
I went, from under the pine trees,
to see if, perchance,
you might be the rider.

—Manyōshū

Katsushika Hokusai
SHŌNENKŌ
Kakemono-e colour-print; 19⅞ × 8⅞ in.; c. 1830-3

The slave of love
locked up in a chest at home
has broken loose
and grabbed at me.

—Hozumi

Hanabusa Itchō
SCENES FROM KYŌGEN (COMIC PLAYS), second scroll
Makimono: two scrolls. Ink, colour and gofun on paper, fine gold
clouds top and bottom, and silver and gold added for details;
13¼ in. high; c. 1710

Ebizō has given up being
an actor.
I regret it happened
to a good actor such as he is,
being an actor myself.

—Ichikawa Hakuen

Katsukawa Shunshō
DANJŪRŌ V IN THE SHIBARAKU ROLE
Kakemono. Ink, colour and gofun on silk, 19⅛ × 9⅜ in.; c. 1788

Come, friend, be gay and sing;
I'll rise and dance!
How can we sleep at ease tonight
when the moon shines so bright?

—Ryōkwan

Torii Kiyonobu
ARASHI SANGORŌ IN THE 'CATCHING THE FOX' DANCE
Kakemono. Ink, colour and gofun on paper; 12¾ × 17⁹/₁₆ in.; c. 1726

中山来助

Moon? There is none.
Where are spring's flowers?
I see not one.
All else is changed, but I
love on unalteringly.

—*Ise Monogatari*

Ryūkōsai Jokei
THE ACTOR NAKAYAMA RAISUKE IN CHARACTER
Hoso-e colour-print; 12½ × 5¾ in.; c. 1800

Since we are such things
that if we are born
we must someday die,
so long as this life lasts
let us enjoy ourselves.

—Anon.

Tosa School
EVENTS THROUGHOUT THE TWELVE MONTHS OF THE YEAR
Makimono. Ink, colour and gofun on paper; 9¾ in. high, with
gold suyari (mist bands) top and bottom; c. 1700

あはれなり
月もろともに
いでしかと
ゆふつけ鳥の
こゑのまつかせ

三井晩鐘

Think not that God
is something distant,
but seek for him
in your own hearts;
for the heart
is the abode of God.

—Kyusō

Nishimura Shigenaga
THE EVENING BELL AT MII TEMPLE
Hoso-ban print; sumi-e urushi-e, hand-coloured; 13⅛ × 6⅛ in.; c. 1730

When evening comes
I turn mine eyes toward the hill,
and I am filled with grief.
When I find myself alone at daybreak,
the rough sleeve of my robe,
moistened with tears,
has not had time to become dry.

—Tenbuyo

My heart, thinking
"How beautiful he is,"
is like a swift river
which, though one dams it and dams it,
will still break through.

—The Lady of Sakanoye

Stronger than a yoke of oxen
is the drawing power
of a single hair of woman.

—Japanese proverb

Kitagawa Utamaro
THE *AWABI* DIVERS (left panel)
Ōban triptych colour-print; right, 14⅝ × 9¾ in.; centre and left,
14¾ × 9¾ in.; c. 1798

If one should ask you
what is the heart
of Island Yamato,
it is the mountain cherry blossom
which exhales its perfume in the morning sun.

—Moto-ori

Chōbunsai Eishi
COURTESAN BENEATH A CHERRY TREE
Kakemono. Ink and colour on silk; 32³/₁₆ × 11⁵/₁₆ in.; c. 1796

A bird that is reared in captivity
may live, grow old, and die,
and never know that it has wings with which
to soar into the sky.

—Ōguchi Taiji

Katsushika Hokusai
CANARY AND PEONY
Chūban colour-print; 10 × 7⁷/₁₆ in.; late 1820s

千葉楊枝二種
東深霸荒芳
王十明

Sleepless with longing
I see the morning sun arise.
Do the mandarin ducks flying by
bring a message from my love?

—Kakinomoto Hitomaro

Wantanabe Shikō
MANDARIN DUCKS
Kakemono. Ink, and slight colour on paper; 42 × 15½ in.; One panel of a four-fold screen; c. 1730-40

This brilliant moonlit night,
for which the crickets longed
and now are gay:
oh, I wish that this September night
would never go away!

—Kamo Mabuchi

Ichiryūsai Hiroshige
NAGAKUBŌ
Ōban yoko-e colour-print; 9⅜ × 14⅛ in.; late 1830s

十八公榮霜後露
一千年色雪中深

O thou bird of Miyako!
If such be thy name,
come! this question I would ask:
Is she whom I love
still alive, or is she no more?

—*Ise Monogatari*

Ichiryusai Hiroshige
MACAW ON A PINE BRANCH
Ō-tanzaku colour-print; 14⅞ × 6¾ in.; early 1830s

Since the day that Arao left,
the waters fished by the folk
 of Shika
are lonely.

—Yamanoé Okura

Kitagawa Utamaro
THE *AWABI* DIVERS (center panel)
Ōban triptych colour-print; right, 14⅝ × 9¾ in.; center and left,
14¾ × 9¾ in.; c. 1798

The white complexions
of the *oharame*
are more noticeable
than the black brushwood
they are balancing on their heads.

—Anon.

Kōkasai Fujimaro
TWO *OHARAME* ON THE BANK OF A STREAM
Kakemono. Ink, colour and gofun on silk; 37½ × 13¼ in.; c. 1800

The land of Yamato
has mountains in numbers . . .
I stand on the summit
my kingdom to view.
The smoke from the plain rises thickly,
the gulls from the sea soar aloft.
O land of Yamato!
thou art dear to me.

—Kakinomoto Hitomaro

Ichiryūsai Hiroshige
ROADSIDE PINES UNDER A FULL MOON AT MOCHIZUKI
Ōban yoko-e colour-print; 9 × 13$^{9}/_{16}$ in.; late 1830s

Ben-ne-Naishi showed on her train
a beach with cranes on it
painted in silver.
It was something new.
She had also embroidered
pine branches.
She is clever,
for all these things are emblematic
of a long life.

—Murasaki Shikibu

Katsushika Hokusai
TWO CRANES ON A SNOWY PINE
Kakemono-e colour-print; 20½ × 9⅛ in.; early 1830s

Indeed, indeed,
I care not how
my grass-made hut is torn:
What matters is—when will you come?
you who are so fickle.

The promised night
has come and gone;
in place of me,
who can have stopped
your bullock-cart?

—The Insect Scroll

Torii Kiyomasu
THE INSECT SCROLL
Makimono. Ink, colour and gofun on paper; 10¹/₁₆ in.; c. 1710-20

清風軼比倫
踢步古今裡
詠吉野山春
思明石浦晨
鳳毛猶步障
麟角已無羣
並上憶其人
味歌長寂寞

梅谿 賛

Who can be matched to the pure wind?
He walked alone in old times and again today,
he who composed poems about Mount Yoshino
and poems about Akashi beach.
It is as if the phoenix stayed with us a little while,
though the kirin disappeared long ago.
For so long Japanese poetry was silent and alone.

—Baikei

Iwasa Matabei
PORTRAIT OF THE POET KAKIMOTO NO HITOMARO
(Attributed to Matabei) Kakemono. Ink and colour on silk; 32¼ ×
14½ in.; c. 1640

So long as I have my pleasure
in this world,
what care I if
in the future world I become
an insect or a bird.

—Ōtomo Tabito

Hanabusa Itchō
SCENES FROM KYŌGEN (COMIC PLAYS), first scroll
Makimono: two scrolls. Ink, colour and gofun on paper, fine gold
clouds top and bottom, and silver and gold added for details;
13¼ in. high; c. 1710

Like a great rock, far out to sea,
submerged at even the lowest tide,
unseen, unknown of man—my sleeve
is never for a moment dried.

—Lady Sanuki

Kaigetsudō Ando
STANDING COURTESAN IN *KIMONO* WITH FERN AND WHEEL PATTERN
Kakemono. Ink, colour and gofun on paper; 31½ × 11½ in.; c. 1710

The dress that my brother has put on
 is thin.
O wind from Sao,
do not blow hard
till he reaches home.

—The Lady of Sakanoye

Suzuki Harunobu
THE WATER-VENDOR
Chūban colour-print; 10 15/16 × 8⅛ in.; c. 1765-6

How sweet to pass away together,
to die together,
in this world of ours
where the clock which strikes
the Supreme Hour
is almost always too fast for one,
or too slow for the other.

—Anon.

Katsukawa Shunshō
ICHIKAWA YAOZŌ II IN THE SHIBARAKU ROLE
Hoso-ban colour-print; 12⅝ × 5⅞ in.; 1774

Who could it have been
that first gave love this name?
"Dying" is the plain word
he might well have used.

—*Kokinshū*

Suzuki Harunobu
THE CLEARING WEATHER OF THE FAN
Chūban colour-print; 11 × 8¼ in.; c. 1766

When autumn comes,
and the river-mists spread over
　　the Heavenly Stream,
I turn toward the river;
and the nights of my longing
　　are many!

— *The River of Heaven*

Ichiryūsai Hiroshige
THE SUMIDA RIVER IN SNOW
Panel colour-print; 15 × 5 in.; 1834

夢にさへ名所の
沙隅田川之雪
あら九川よの
くくゆる雪の
きえの乃るゝ数是うら

Its burning fire is quenched by the snow;
the snow that falls is melted by the fire.
No words may tell of it,
no name know I that is fit for it,
but a wondrous deity it surely is!
That lake we call the Sea of Se
is contained within it;
that river which men, as they cross it, call Fuji
is the water which flows down from it.
Of Yamato, the land of Sunrise,
it is the peace-giver, it is the god,
 it is the treasure.
On the peak of Fuji, in
 Suruga,
I never weary of gazing.

—Anon.

Katsushika Hokusai
FUJI FROM HODOGAYA ON THE TOKAIDŌ
Ōban yoko-e colour-print; 10⅛ × 15⅞ in.; late 1820s

Would it now be possible
for me to pass one moment
of my life
without seeing thee—
though that moment were short
as the intervals
between the joints of reeds
growing by the shores of Naniva?

—Anon.

Kaigetsudō Anchi
COURTESAN STANDING WITH RAISED LEFT HAND
Kakemono. Ink, colour and gofun on paper; 37 × 16 in.; c. 1715

My love
is like the grasses
hidden in the deep mountain:
Though its abundance increases,
there is none that knows.

—Ono Yoshiki

Baiōken Eishun
SEATED COURTESAN
Kakemono. Ink, colour and gofun on paper; 41⅛ × 19⅞ in.; c. 1725

Has not bravery itself
its root in goodness of heart,
and does it not proceed from sympathy?
It is only when it cries from goodness
that bravery is genuine.

—Kyusō

Torii Kiyomasu II
SEGAWA KIKUNOJŌ IN A *SAMURAI* ROLE
Print: hoso-ban, sumi-e, urushi-e, hand-coloured; 12⅜ × 5¹⁵/₁₆ in.; c. 1735

瀬川福村丸

〈元板屋形鱗△筆倍清居鳥師絵〉

Avarice and cowardice
are the same.
If a man is stingy
of his money
he will also grudge
his life.

—Kyusō

Tōshūsai Sharaku
ICHIKAWA EBIZŌ IV AS SADANOSHIN
Ōban colour-print; 14¾ × 9¾ in.; 1794

You often did not come
when you said you would,
so I don't expect you tonight,
since you said that you would not.

—Sakano-e Iratsume

Furuyama Moromasa
COURTESAN OF ISE-YA AND ATTENDANT
Kakemono. Ink, colour and gofun on paper; 32 1/16 × 11½ in.; c.1720